Brassaï

Introduction by Roger Grenier

Thames and Hudson

On the cover: The Kiss, Paris, 1935-37.

First published in Great Britain in 1989 by
Thames and Hudson Ltd, London.
Originally published in France by Centre National de la
Photographie.
Copyright © 1987 by Centre National de la Photographie.
Photographs © 1987 by Gilberte Brassaï.
Text copyright © 1987 by Roger Grenier.
English translation copyright © 1988 by Random House,
Inc.

Printed and bound in Italy.

Brassaï

For forty years I enjoyed the privilege of friendship with Brassaï. I saw him draw, sculpt, film, write, collect stamps, build a shadow puppet theater, draw up chronological tables of world history, create stage settings for ballet, and design tapestries. I don't think I ever saw him take pictures. It was as if, for the artist, this was the most intimate, the most secret part of his life. There was also perhaps a rejection of what one likes the best, a love-hate factor, and in Brassaï's case, a refusal to allow himself to be confined to one specialty, that of being a great photographer – that is, being *only* a great photographer.

One of the most characteristic incidents of his life, it seems to me, happened in Louisiana: He dropped his Rolleiflex into a bayou. It would be hard to do anything more absurd or ridiculous. In truth, when you saw Brassaï, with his slightly bulging eyes constantly darting here and there, always on the lookout, you'd think that he didn't need anything else to capture the richness and diversity of the world. His friend Henry Miller called him "a living eye." It was the insatiable curiosity of that eye, and of the brain that is the extension of the retina, that made him the most complete artist and witness of his time. When I referred to what I called his Leonardo da Vinci side, he replied modestly, "Absolutely. Leonardo da Vinci would have been better off not being a jack-of-all-trades but mixing his colors more carefully so they could have stood the test of time. Pretty soon there won't be anything left of his paintings."

"Spend a few hours with him," Henry Miller once wrote, "and you have the feeling that you're being dragged through a large sieve which has retained a little of all that contributes to the exaltation of life." He meant that this photographer, this painter, this sculptor, this writer, knew how to see everything, and, solely by paying attention, he accorded reality a quality and a coherence that made the world both more strange and more immediate. He photographed the pimps at the Bastille and the members of the Jockey Club, the porters of Instanbul and Bonnard in his studio. He made notes

of the comments made by Marie, his housekeeper, and those of Picasso. And the result is still rich in meaning.

This same passion for life made him a prodigious raconteur, who could regale you all night long with stories. But one mustn't jump to the conclusion that he was no more than his hilarious anecdotes, at the Hôtel des Terrasses, rue de la Glacière, with his Bohemian friends Michaux, Prévert, Queneau, Henry Miller, Alfred Perles, Reichel, Marchel Duhamel... "Michaux and I roamed all over the port at Antwerp one night in 1936 without seeing a single boat. I still don't understand why." He had a thousand stories like that; but his flair as a story teller was mixed with a gift for profound reflection. He was blessed with a philosophical spirit; in fact, his model of greatness was Goethe. Hence it would be a betrayal to recount only those great stories of Montparnasse in its heyday. He was full of humor, but without a trace of mockery. In the face of the most eloquent or the most trivial expression of life, he seemed to say, That too exists, and deserves attention. That was his idea, and the secret of his art.

He thus made us sensitive to the truth not only of human beings, but also of things, and even materials. His obsession with materials showed up in his photos of scaling walls, in black and white and in color. These pieces of stone, of plaster, of cement, are not just proof of the reality of the tangible world; they are inscribed with a network of signs. Beginning in 1932, he went in pursuit of graffiti.

"Brassaï is a revealer of unknown microcosms of which time invisibly accumulates the vestiges," François Mauriac wrote. "Thus did photography reveal the imprint of the Son of Man on the Holy Shroud. Thus did the imprint of man appear faintly on Brassaï's sordid wall."

I do not believe that Veronica, as Alfred Jarry would have liked, was the ancestor of photojournalists, but I think that we always have need of an artist who teaches us how to look at things. Without Brassaï, I don't know if we would have paid any attention to walls, whether they are covered with skulls and hearts pierced with arrows, or whether their dilapidation makes them resemble abstract paintings. "But, Brassaï," Henry Michaux exclaimed, "you have found all of today's art on the walls of Paris!" The photographer was fully aware of this. He was truly a prophet back in 1933, when he wrote an article for one of the first issues of *Minotaure* entitled

"From Cave Walls to Factory Walls": "The bastard art of the streets of ill repute, which does not even arouse our curiosity, so ephemeral that it can be wiped away by a rainstorm or a coat of paint, becomes a criterion of value. Its law is formal, overturning all the canons so laboriously established by aesthetics."

He loved to paraphrase Flaubert in saying that life provided only the accidental, and that the task of the artist was to transform the accidental into the immutable. He also said that to attain the surreal, one needed to start from the most mundane reality, that the humble and sincere search for that reality imperceptibly led to the fantastic.

In 1933, speaking of Brassaï's *Paris by Night* in *Le Temps*, Emile Henriot pointed out that it revealed a new way of feeling reality. "In the strictest sense this is a true work of art, because out of a hundred or ten thousand proofs that could be given for a single viewpoint, there is one, signed Brassaï, that gives us the impression of novelty, of a total renewal through its style, thereby prompting an emotion that is born of the unexpected spectacle of nature recreated by man. *Homo additus naturae* – that is the definition of art, and it has been true since Bacon. It is impossible to see how it could be any the less true merely because it is applied to a photograph. Photographer of 1933, you are working for the year 2000, and you'll be found to have plenty of talent."

Not only does Brassaï help us to better understand living beings and inert matter, he also seems to have penetrated the secret of light and night. Diane Arbus, who felt his influence early in her career – she was introduced to his photos by Brodovitch and Marvin Israël of *Harper's Bazaar* – maintained that he taught her what I would call a lesson in darkness. She even spoke of it in her last class, as Patricia Bosworth recounts in her biography: "Brassaï taught me something about obscurity, because for years I had been hipped on clarity. Lately, it's been striking me how I really love what I can't see in a photograph. In Brassaï, in Bill Brandt, there is the element of actual physical darkness, and it's very thrilling to see darkness again."

It is true that Brassaï became part of the history of photography as the man of the night. As a young painter, he arrived in Paris in 1924, an era when the marvel of the Left Bank kept people from all over the world awake all night, a time when no one ever slept. The beauty of Parisian nights

led Brassaï to a means of expression that up till then had left him cold: photography. He found that photography let him render a certain aspect of streets at night that he could never attain with paints. Thus, the first to do it, he photographed Paris night after night.

He ventured into the most deserted areas along the Canal Saint-Martin. Afterwards, he said, "To gauge my shutter time, I would smoke cigarettes – a Gauloise for a certain light, a Boyard if it was darker. The policemen on patrol wondered what kind of crime I was in the midst of committing. They had never seen anyone taking pictures at night and for good reason. To clear myself, I always had some prints with me to show them. I have noticed that policemen are always very interested in photography. So they immediately became friendlier."

Leon-Paul Fargue, the self-styled "Pedestrian of Paris" – of whom Brassaï made a wonderful nighttime portrait sitting on a bench bathed in the light of a street lamp – would drag the photographer along with him as far as the outskirts of the city, to the Porte des Lilas. "One night," Brassaï related, "he wanted to bring along Edmond Jaloux. It was foggy, and the streets were muddy. Jaloux didn't at all like walking around in such sinister streets, and he got away as fast as he could. Fargue just sighed and said, 'What can you do? Poor old Jaloux is really unimaginative!' "

He quickly replaced his amateur's camera with a 6×9 Bergheil de Voigtlander, with an f/4.5 lens. He stayed faithful to that model for a long time, even buying new ones three or four times. He rented a second room at the Hôtel des Terrasses to use as a darkroom.

All of that resulted in an album, *Paris de nuit* (*Paris by Night*), with a text by Paul Morand. It was published in 1933 and today is a classic.

Brassaï was born in 1899 at Brasso, in Transylvania, a part of Rumania that then belonged to Hungary. He adopted his hometown's name as his own. His father, who taught French literature, took a year's sabbatical in Paris, so Brassaï discovered France at the age of five. He stored up a collection of images even then: "In the Avenue du Bois, I would often watch the men and women riding horses, the sports teams, and the first automobiles. At the Champ de Mars, I saw Buffalo Bill and his gigantic circus with the cowboys, Indians, buffalos, and

Hungarian Csikos. At the Théâtre du Chatelet, I was enthralled by a fantastic spectacle entitled *Tom Pitt*, and I was at the ceremony welcoming Alfonso XIII to Paris. He drove down the Champs-Elysées in a carriage with President Loubet, surrounded by the mounted Republican Guards. The parade sped along very quickly for fear of an attack by anarchists. But I especially remember the Latin Quarter and the Luxembourg. My brother and I knew it inside out. While Father was in class at the Sorbonne or attending seminars at the Collège de France, we sailed our boats in the big fountain."

Back in Brasso, the boy began to dream. Now that Paris was out of reach, it was all the more desirable. His father, the French teacher, had always said that he hoped one of his sons would live in Paris. Only now there was the First World War, and after 1918, the citizens of formerly hostile countries were not allowed in France. To study painting, the young Brassaï – who as a student in Budapest had been mobilized in 1917 to serve in the Austro-Hungarian army, had to go to Berlin. He enrolled at the Akademische Hochschule in Berlin-Charlottenburg, and also worked in the free schools. Artistic, literary, theatrical, and musical life was intense. He knew artists like Kokoschka, Kandinsky, Jean Pougny, Larionov...

Finally in 1924 he was able to return to Paris. As in Berlin, he continued his sculpture, drawing, and writing. Then he discovered photography. When Skira and Teriade founded a sumptuous art review, the *Minotaure*, in the 1930s, they asked him to photograph the studios of certain artists, including Giacometti. At the *Minotaure*, he met the surrealists Paul Eluard, Salvador Dali, Benjamin Peret. For André Breton he illustrated *La Nuit de tournesol*. Still at the *Minotaure*, Brassaï did photos of nudes, busts that strangely resembled what he was also doing in drawing and sculpture.

During that same period he met Picasso. In his impressive Hispano-Suiza, the painter drove Brassaï to Boisgeloup to photograph his sculptures. Some of the photos were lit by the headlights of the Hispano. The next day, Picasso invited him to come with him and his family to the Medrano circus. That is how Brassaï became one of Picasso's close friends, visiting him at his place on rue La Boëtie, then rue des Grands-Augustins and, later, in Cannes and Mougins. *Conversations avec Picasso* (Gallimard, 1964) was born of that long friendship. One of Brassaï's first literary works, *Histoire de Marie*, was an astonishing experiment in which he reconstructed his

houskeeper's comments, rendering them so realistically that the reader had the feeling he had always known Marie. Brassaï did somewhat the same thing for Picasso. Around that central figure, his close friends and visitors – Prévert, Eluard, Reverdy, Sartre, Camus, Cocteau, Michaux – come back to life. But the work goes beyond the anecdotal, displaying Picasso's genius and the questions raised in his art. There had already been dozens of books on the painter, but never had he been so present, never so well understood. Picasso, who avoided reading books about himself, read this one. He decided to organize an exhibition in Cannes of twenty or so sculptures and photographs taken from the book. One day he showed the book to Ilya Ehrenburg and said, "If you really want to know me, read this book."

After the war, Paris's nocturnal rover became a globe-trotter. This change resulted from a long and fruitful collaboration with *Harper's Bazaar*. Carmel Snow and Alexey Brodovitch not only asked him to photograph Bonnard, Braque, Giacometti, and Le Corbusier; they also sent him to Greece, Turkey, Morocco, the Arctic, Sicily, Brazil, the United States, England, and Ireland. In Italy, he immortalized the grotesque sculptures in the park of Bomarzo, then a place gone wild, where hunters and their dogs roamed freely. In Spain, he made up a whole album on Holy Week in Seville. In New York, the skyscrapers photographed at night in color became blue and pink diamonds. I always associate these pictures with Scott Fitzgerald's exclamation when talking of one of his first loves, Ginevra King, "She made the roof of the Ritz light up!"

As with each discovery of a new means of expression, Brassaï went straight to the heart of it. About these photos he said, "The important thing in color is color."

In 1963, the French National Library mounted a major exhibition in his honor. But, aside from that, only his sculpture, drawings, and tapestries could be seen in Paris. His literary studies were talked about – *Henry Miller grandeur nature* (Henry Miller Life-Size) and *Henry Miller rocher heureux* (Henry Miller, the Happy Rock) – as were his albums, *Le Paris secret des années 30* and *Les Artistes de ma vie* (The Secret Paris of the Thirties, Artists in My Life). During this period, his photography was acclaimed in other countries. In 1968, New York honored him with an exhibition at the Museum of Modern Art. It was his third at this museum, which mounted a

traveling exhibition of seventy-five photographs that went to Australia, New Zealand, and South America. His works were also shown in Washington, Baltimore, and the larger U.S. university cities, as well as in London, Brussels, Antwerp, and Zurich. When he received press clippings from the far corners of the earth praising his photos, Brassaï told me that they seemed like distant echoes that had taken fifty light-years to reach him. Through them he understood the value and the impact of what he had done. They were marked for posterity.

On July 16, 1974, in Arles, Brassaï enjoyed his most overwhelming success. During the fifth International Days of Photography, a unique event was organized. In the Archbishop's Courtyard he showed slides of a hundred or so of his photos and commented on them. Funny, precise, human, he conquered the entire audience. That night photographers from the world over paid him homage that I will never forget.

This tireless person would on occasion fall ill. I never saw such a spectacle as a hospital room occupied by him. In no time at all the walls were papered with photos, the cupboards bulged with manuscripts and files, the bed was buried under avalanches of paper. The typewriter was hospitalized as well. And, as he turned his charm on, full force, not only did the nurses not say a thing about the liberties he was taking; they grew entirely devoted to him.

Brassaï loved to write. Every time he made up an album, he had to complete each photograph with a caption, which soon expanded into a story. His albums are as much to read as to look at.

At the end of his life, he found a way to reconcile his two big passions, photography and literature. He set about writing an essay on Proust and photography. The piece was more or less finished, and when it is published we will see that Proust, in real life as well as in his writings, was completely obsessed by photography.

Brassaï died in Nice on July 7, 1984. According to his wishes, he was buried in the Montparnasse Cemetery, the closest he could be to the place he helped make a legend and for which, in being the first to immortalize its nocturnal life on photographic plates, he was the irreplaceable historian.

Roger Grenier
Translated by Marianne Tinnel Faure

BRASSAÏ

1. Rue de Rivoli, Paris, 1937.

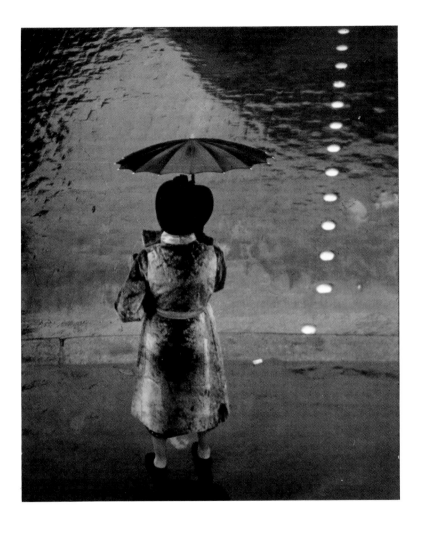

2. Rue de Passy, Paris, about 1940.

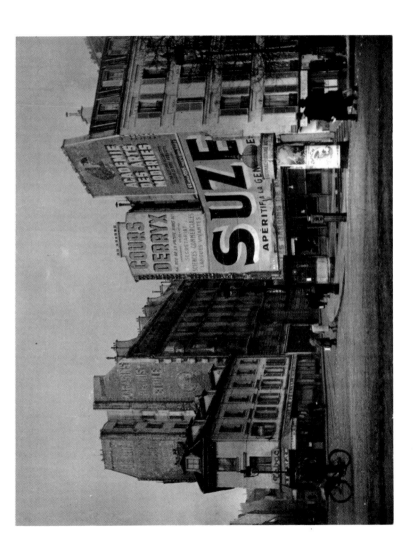

3. Watchmaker, Passage Dauphine, Paris, about 1931-33.

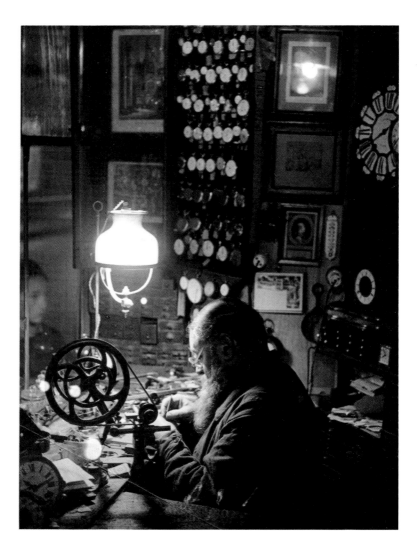

4. Parc Mountsouris, Paris, 1936.

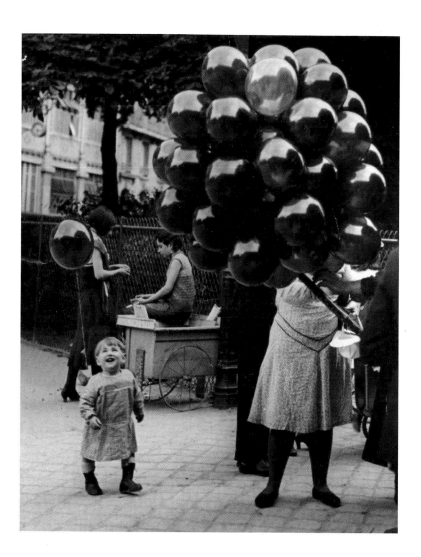

5. Montmartre, Paris, 1936.

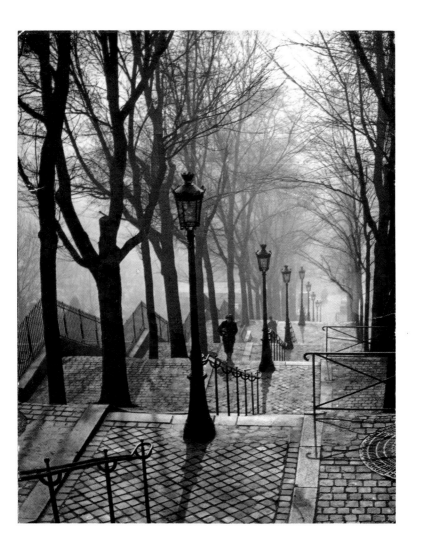

6. Louis Dimier, member of the Institute, on the quays, Paris, 1932-33.
Overleaf: Little white dog, Montmartre, Paris, 1932.

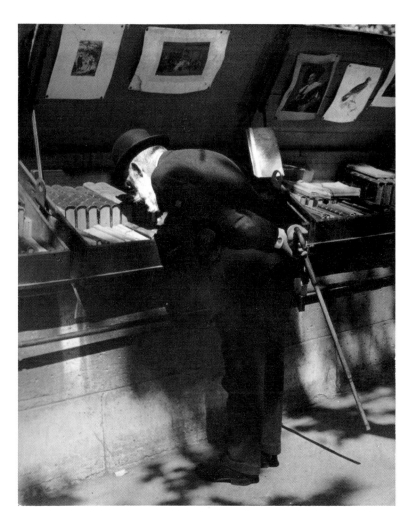

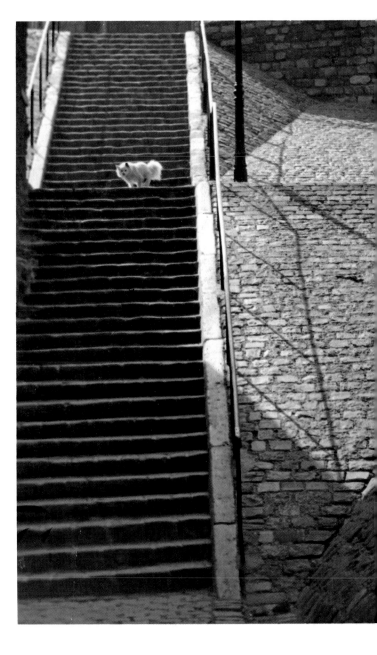

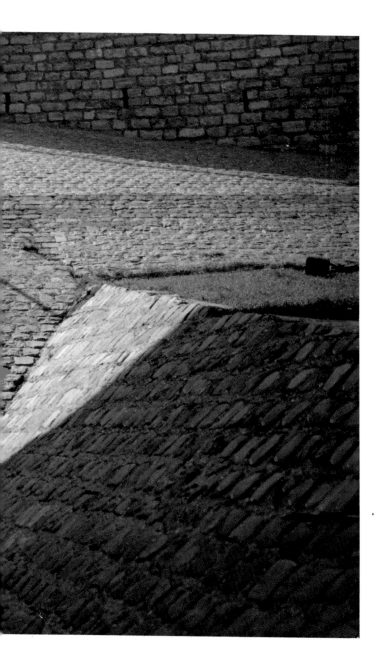

8. Avenue de l'Observatoire, Paris, 1933.

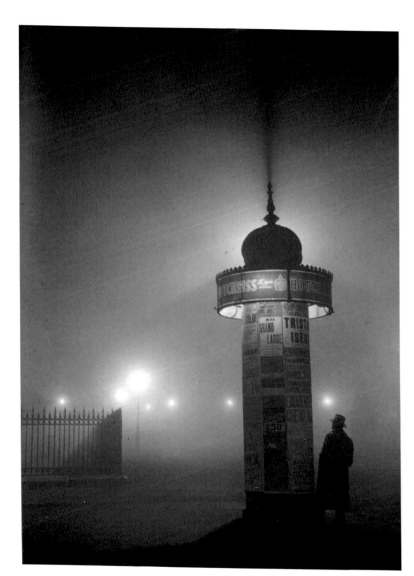

9. The viaduct at Auteuil, 1932.

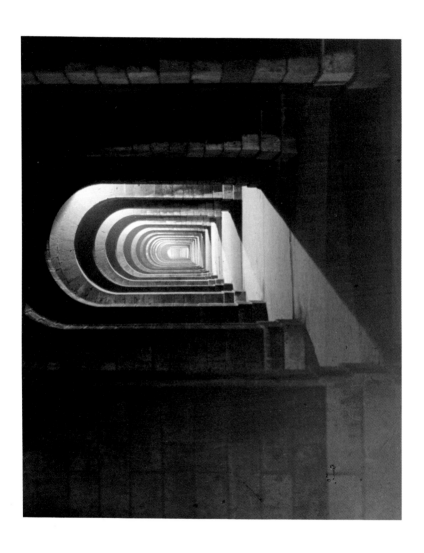

10. Pont-Neuf, Paris, about 1934-1935.

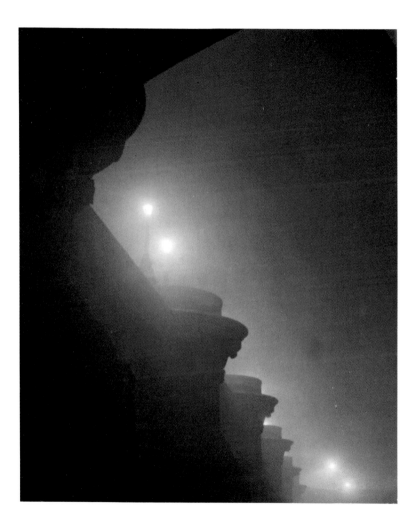

11. Pont-des-Arts, Paris, 1936.

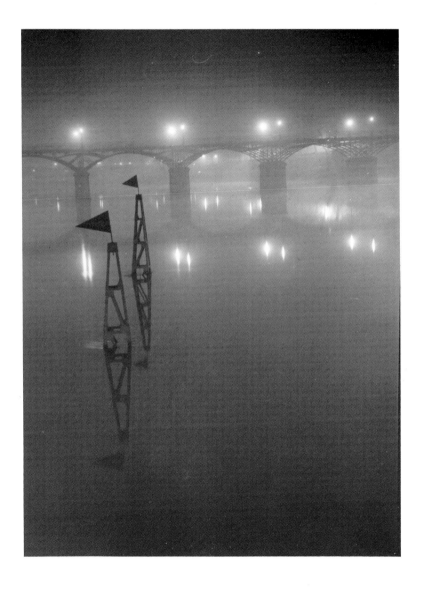

12. Police station, Paris, 1944.

13. Newsstand, Place Denfert-Rochereau, Paris, 1948.

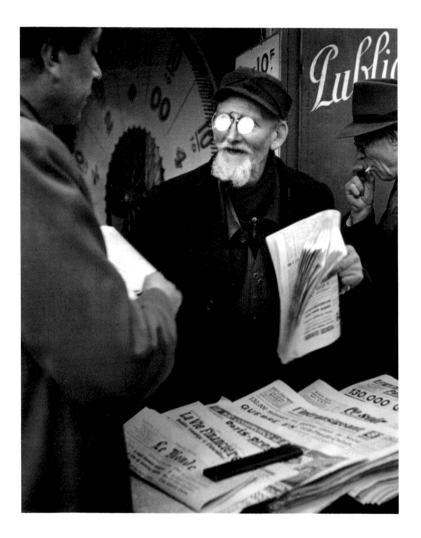

14. Le Dôme, Montparnasse, Paris, 1932.

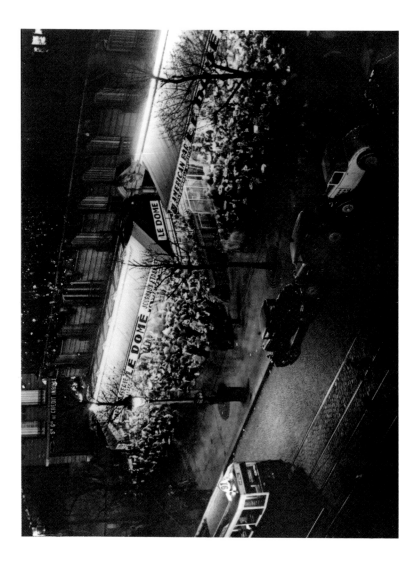

15. Bal des Quatre Saisons, Paris about 1932.

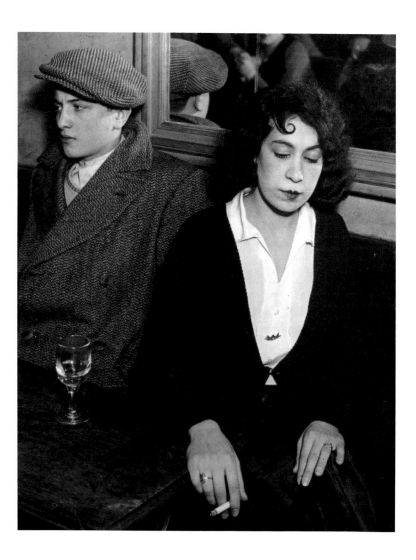

16. Bijou at the Bar de la Lune, Montmartre, Paris, 1932.

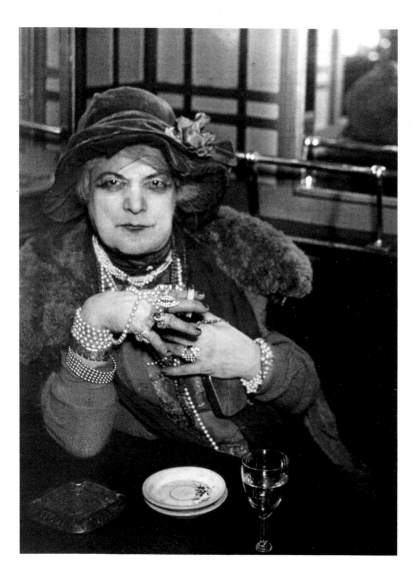

17. Two friends, Paris, about 1932.

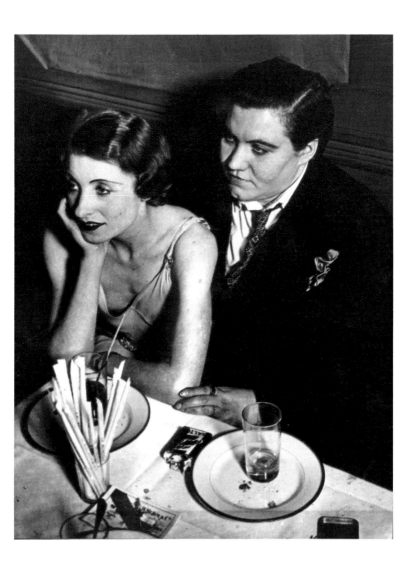

18. In a café, Paris, about 1932.

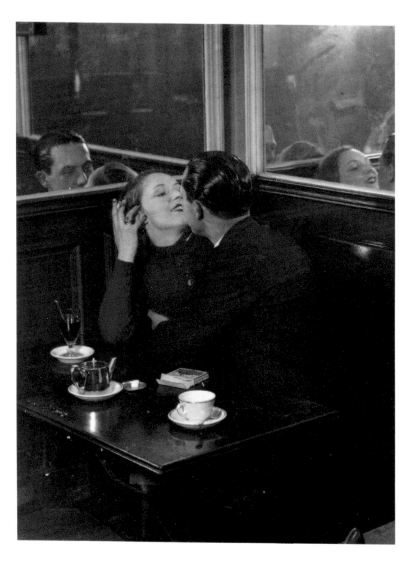

19. Bal de la Montagne Sainte-Geneviève, Paris, about 1932.

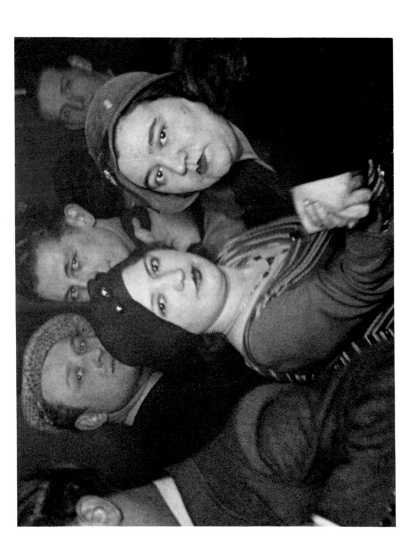

20. Jean-Paul Sartre, café de Flore, Paris, December 1945.

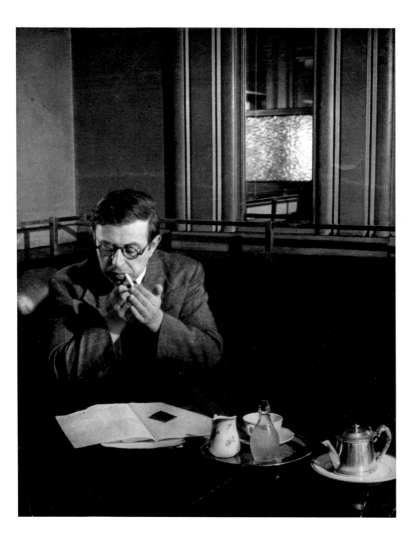

21. Maxim's, Paris, 1949.

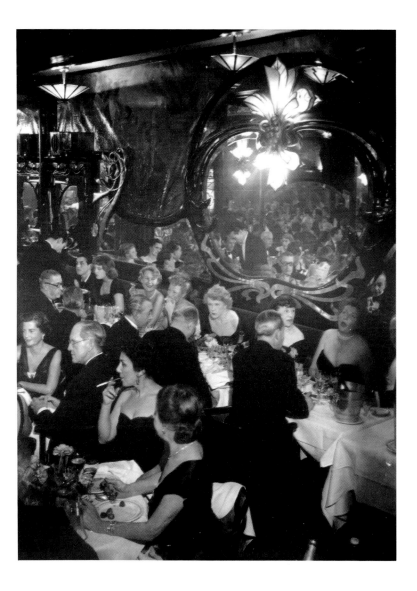

22.Taking a break, Paris, about 1946.

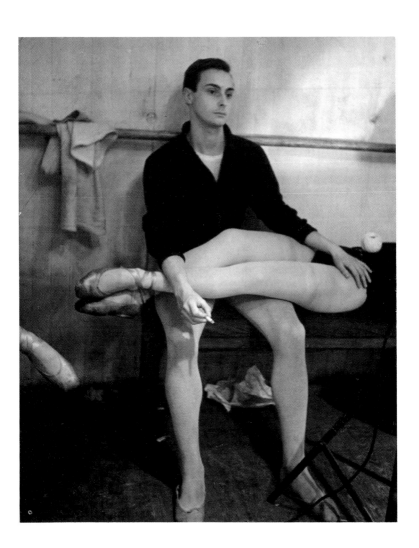

23. At the Paris Opéra, 1937.

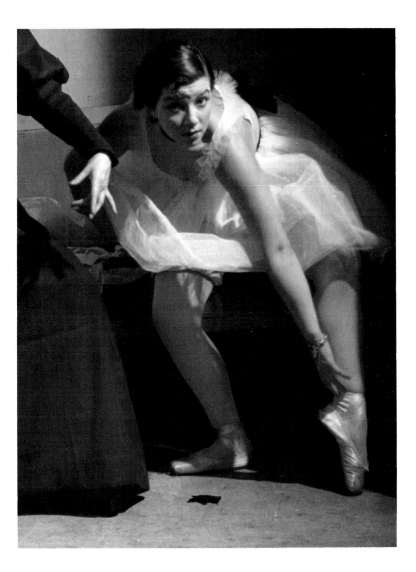

24. Chorus girls, backstage at the Folies-Bergère, Paris, about 1932.

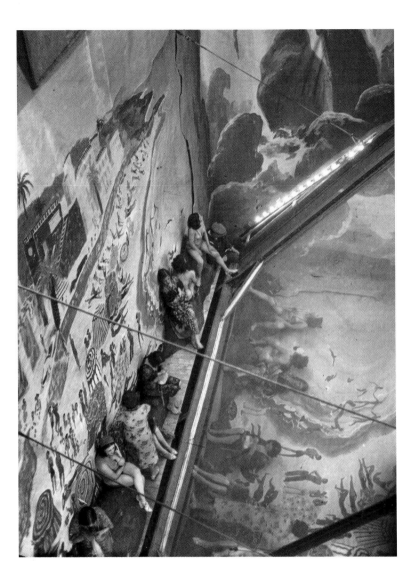

25. Night moth, about 1930-31.

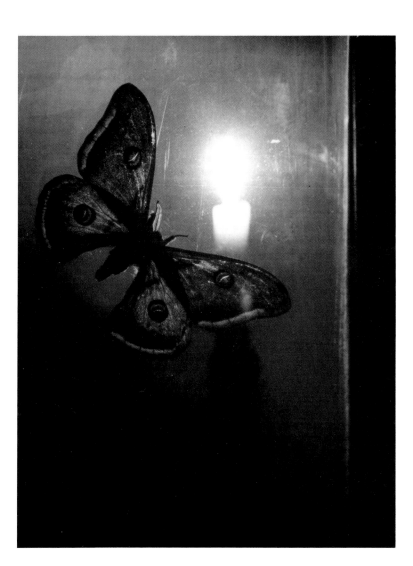

26. "King Kong," Montmartre, Paris, about 1933.

Overleaf: Kiki de Montparnasse and two friends,
Paris, about 1932.

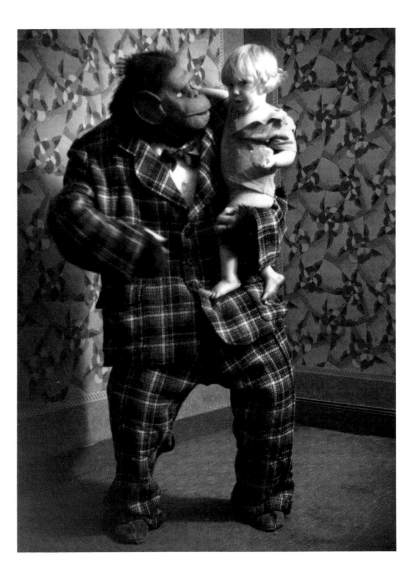

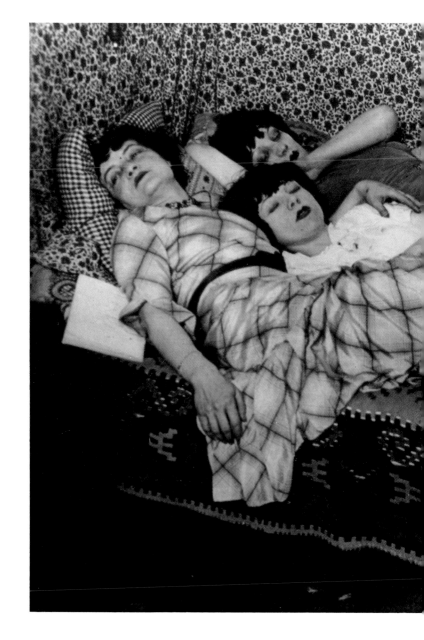

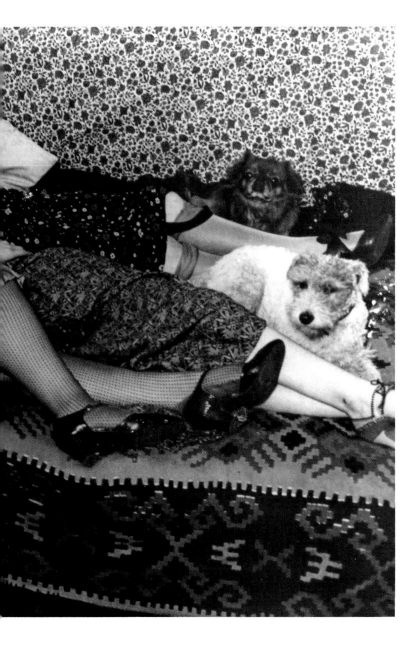

28. Bal du Magic City, Paris, about 1931.

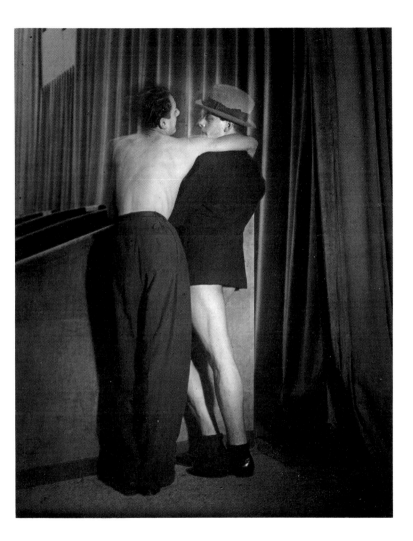

29. Graffiti, 1950.

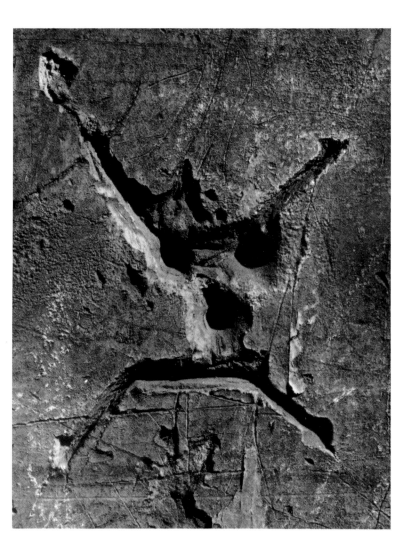

30. Two toughs, Place d'Italie, Paris, about 1932.

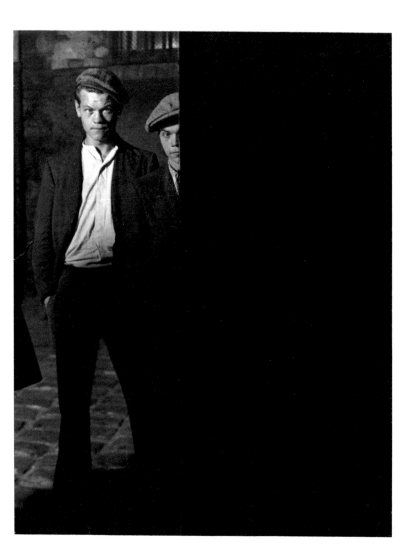

31. The wall of La Santé prison, Paris, 1932.

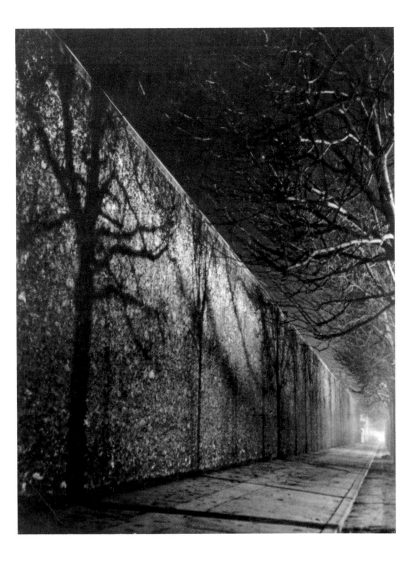

32. Graffiti: Hanged man, 1932-33.

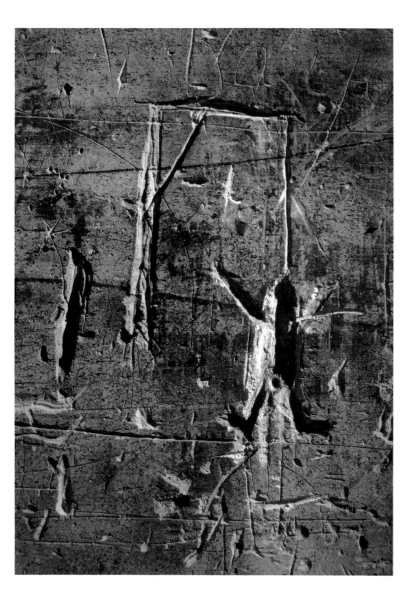

33. Rue Quincampoix, Paris, about 1932.

34. Near the Place d'Italie, Paris, 1932.

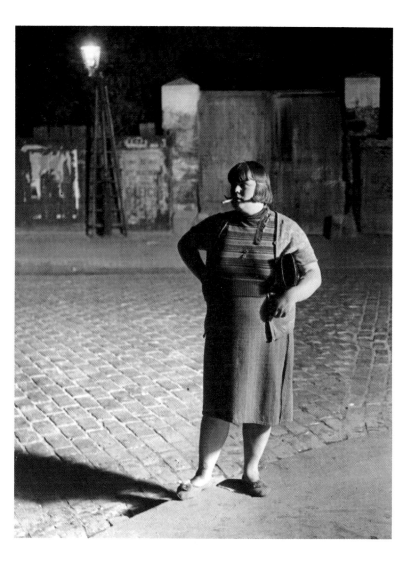

35. Boulevard du Montparnasse, Paris, 1931.

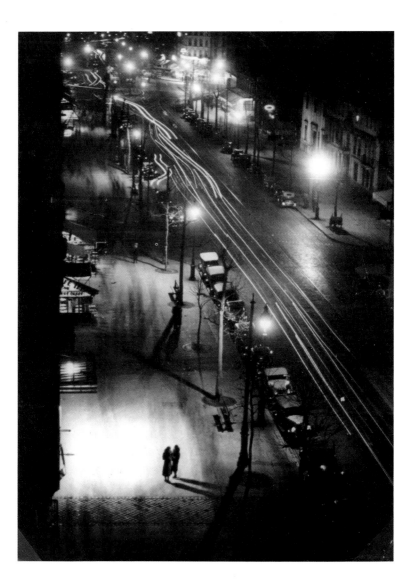

36. Brothel, rue Monsieur-le-Prince, Paris, about 1931.

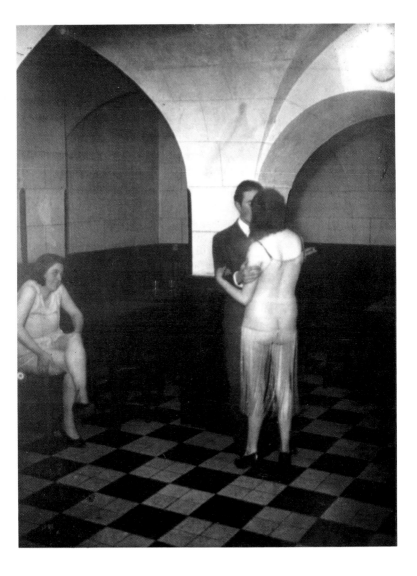

37. "Chez Suzy," rue Grégoire-de-Tours, Paris, about 1932.

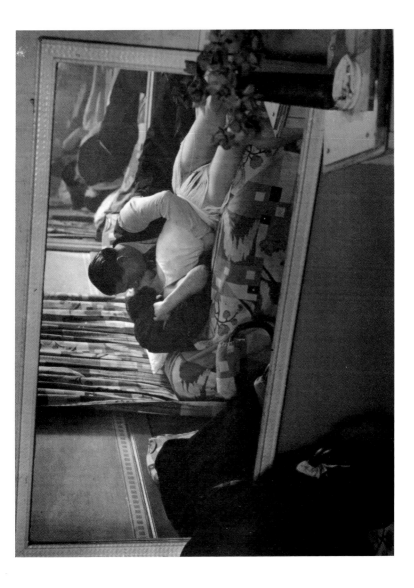

38. In a streetwalker's hotel room, rue Quincampoix, Paris, about 1932.

Overleaf: Paris and the Tour Saint-Jacques, seen
from Notre-Dame, 1933.

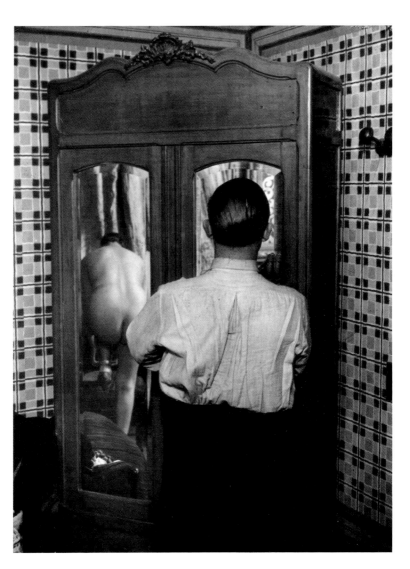

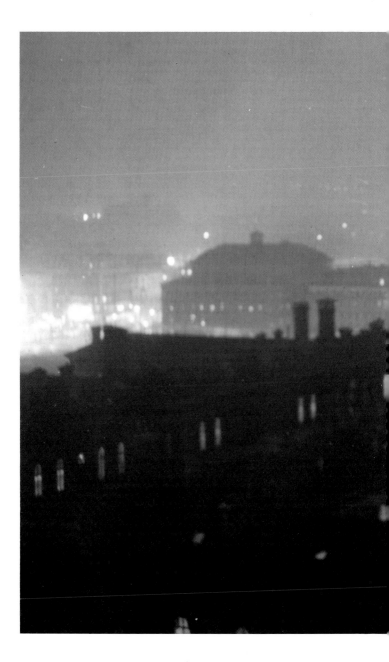

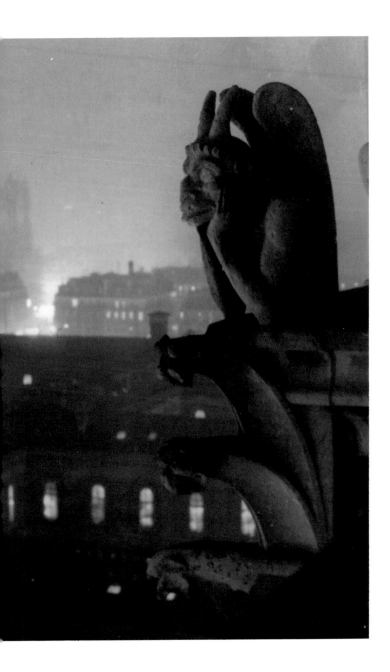

40. "Marlène," Paris, about 1937.

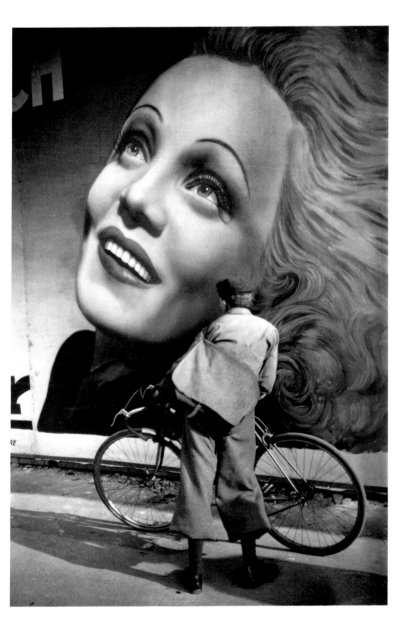

41. Graffiti, The Sun King, about 1945.

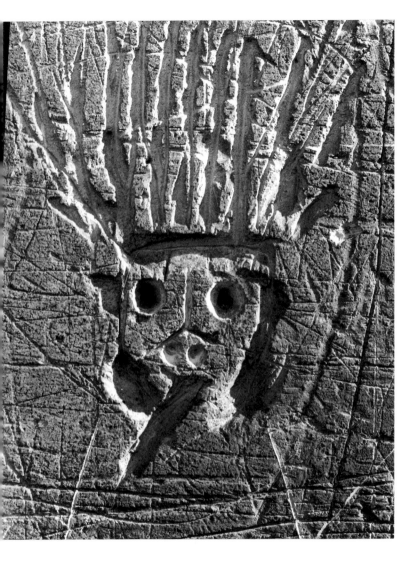

42. Place Saint-Jacques, Paris, 1945.

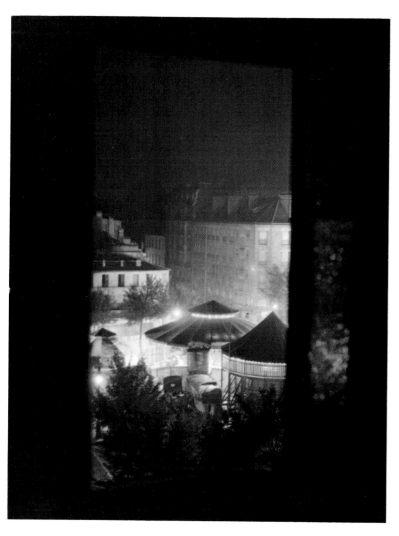

43. André et Paulette, 1949.

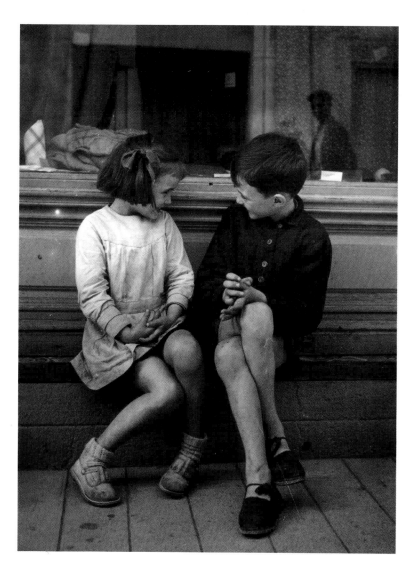

44. The liberation of Paris, Place Denfert-Rochereau, 1944.

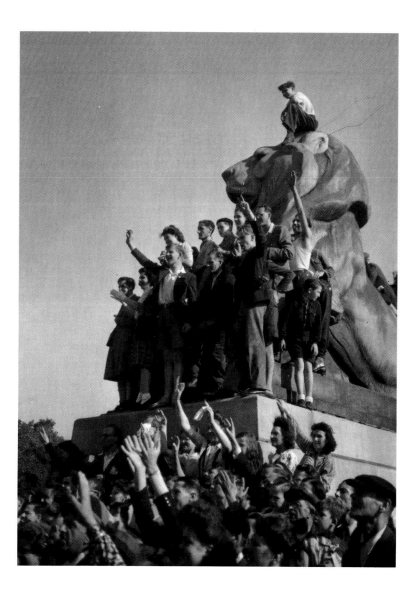

45. On the Rome-Naples train, 1955.

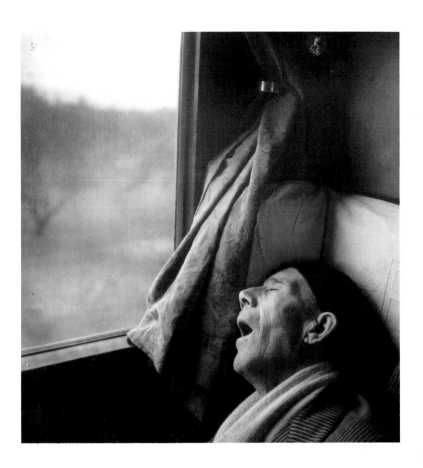

46. The Hospices de Beaune, 1951.

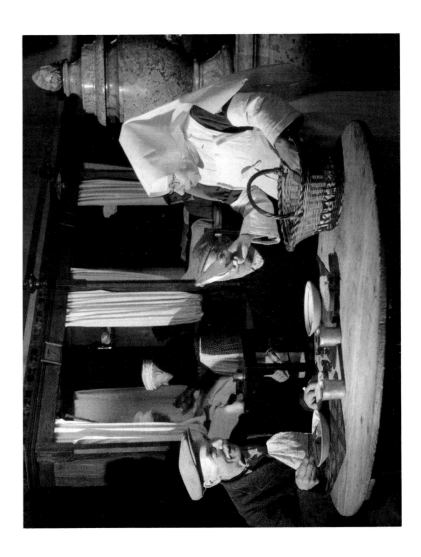

47. The Exotic Gardens, Monaco, about 1945.

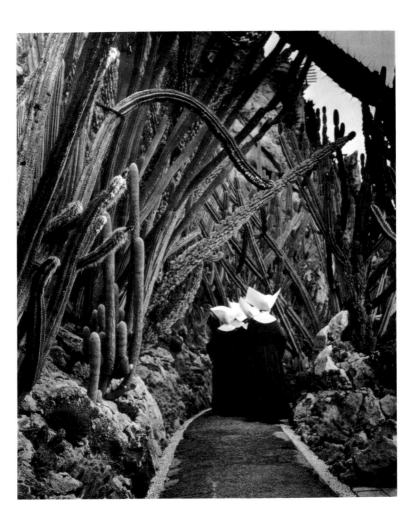

48. Villa Orsini, Bomarzo, Italy, October 1952.

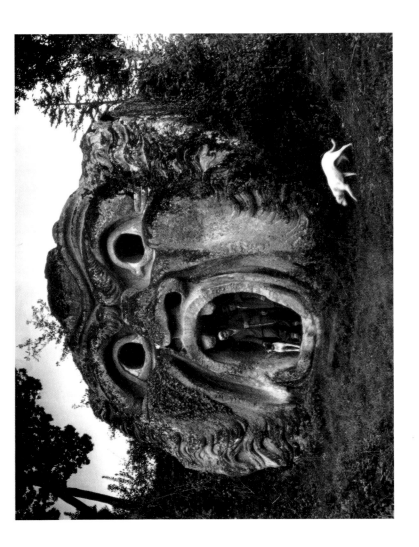

49. Instanbul, 1953.

50. Madrid, 1950.

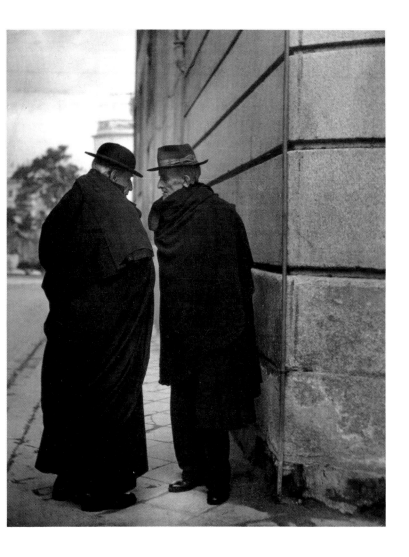

51. Marrakesh, 1950.

52. Giacometti, Paris, October 1947.

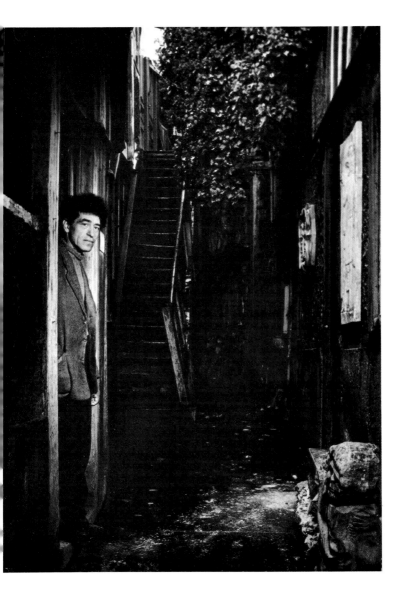

53. Bonnard's studio, Le Cannet, October 1946.

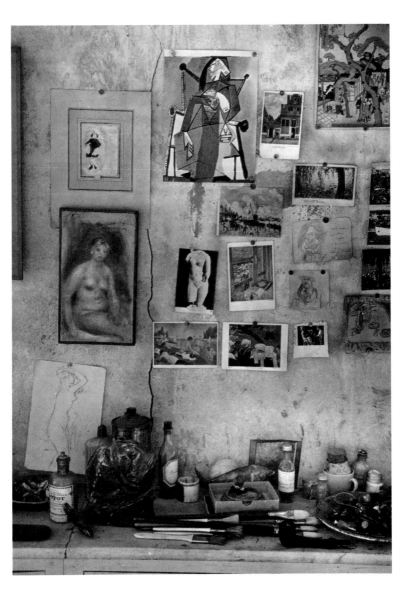

54. Picasso's studio, rue des Grands-Augustins, Paris, May 9, 1944.

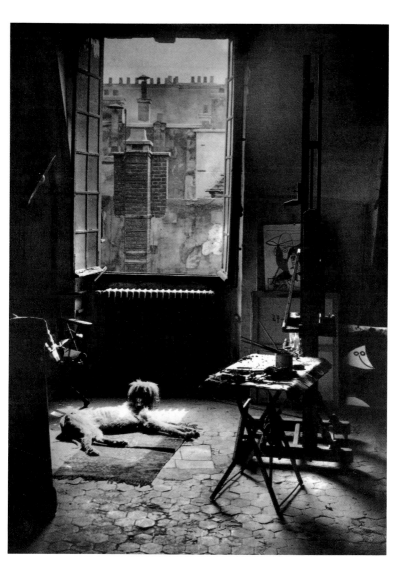

55. Picasso in his studio, rue des Grands-Augustins, Paris, September 1939.
Overleaf: Dali and Gala in their studio near Parc Monsouris, Paris, about 1932.

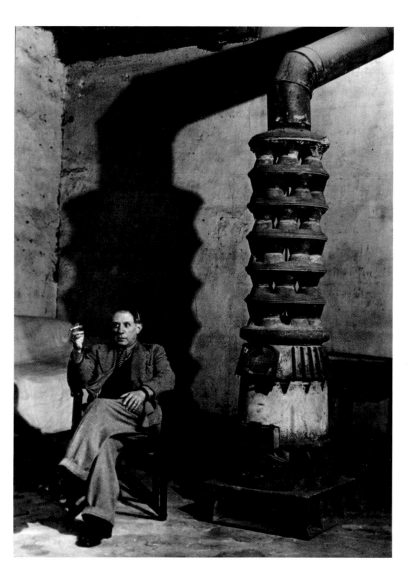

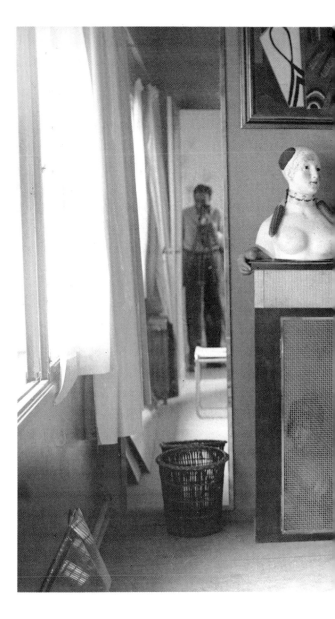

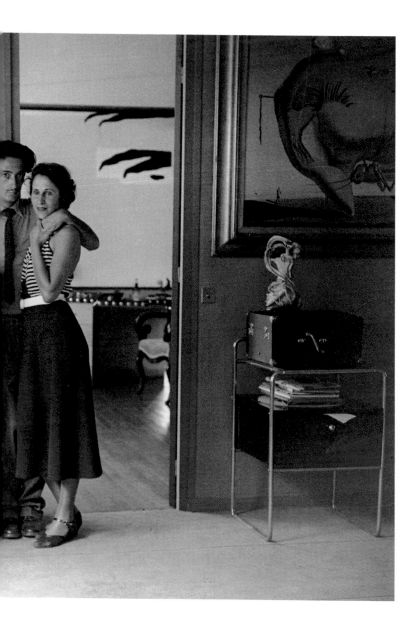

57. Matisse in his studio, Paris, 1939.

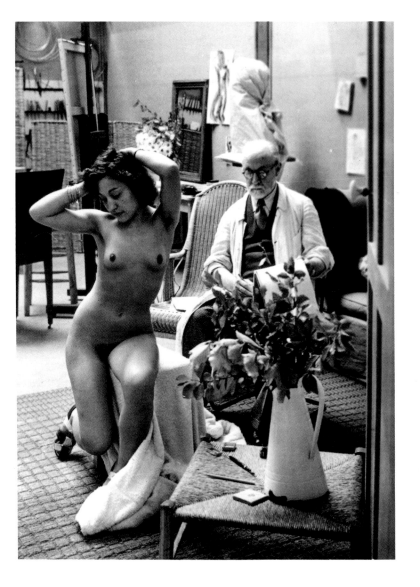

58. Maillol, age 75, Marly-le-Roy, 1936.

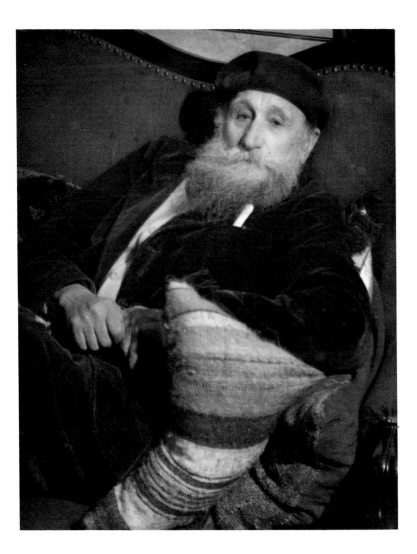

59. Thomas Mann and his wife, July 2, 1955.

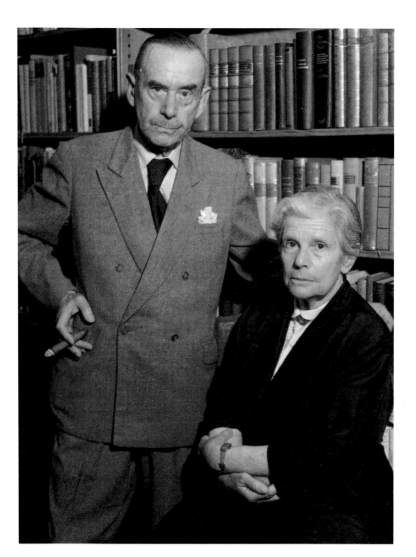

60. Paul Claudel and his wife, May 1949.

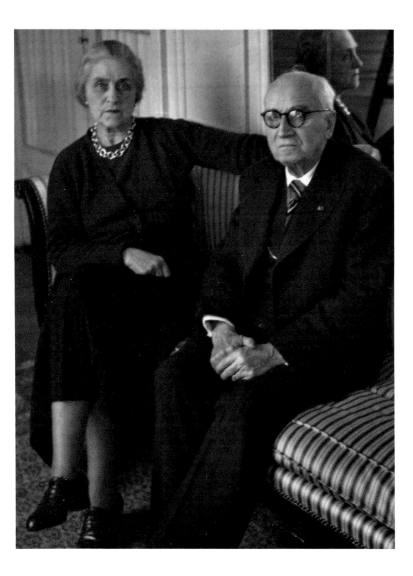

61. Henri Michaux, about 1943-1945.

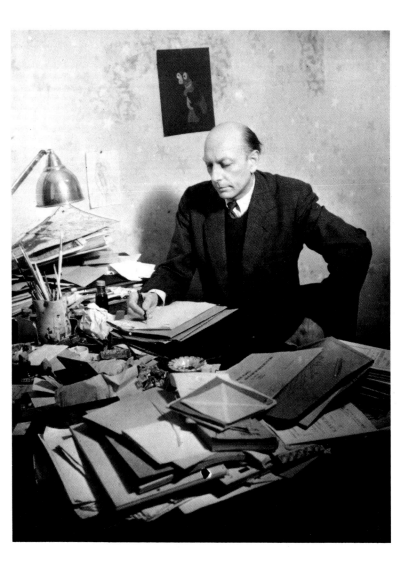

62. Henry Miller, Paris, 1931.

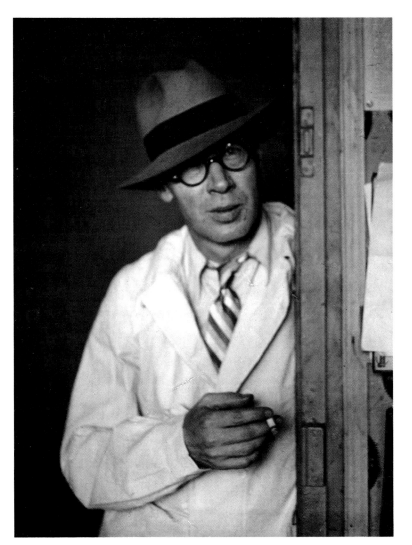

63. Self-portrait, Hôtel des Terrasses, Paris, about 1931.

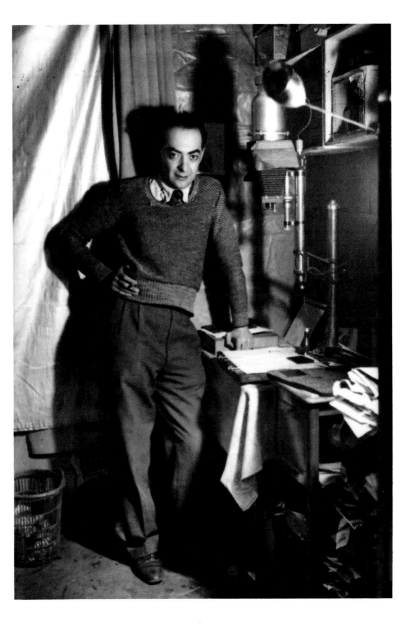

BIOGRAPHY

1899. Born Guyla Halasz on September 9 at Brasso in Transylvania, Hungary (today part of Rumania). His father, a professor of French literature, had studied at the Sorbonne.

1903-04. Lives in Paris, on rue Monge, when his father was granted a year's sabbatical.

1905. Upon returning to Hungary, studies first in Brasso then in Budapest.

1917. Meets Béla Bartók.

1917-19. Takes classes at the Academy of Fine Arts in Budapest.

1921. Arrives in Berlin, late December 1920. Gets to know Moholy-Nagy, Kandinsky, Kokoschka.

1921-22. Attends the Academy of Fine Arts at Berlin-Charlottenburg, earning a diploma.

1924. Arrives in Paris, where he first finds work as a painter and journalist.

1925. Adopts the name Brassaï (literally, from Brasso).

1926. Meets André Kertész. Through his friend Maurice Raynal, art critic at *L'Intransigeant*, is in contact with E. Tériade, Léger, and Le Corbusier.

1930. Fascinated by the nocturnal life of Paris, he becomes a photographer. Out of his nighttime walks comes *Paris de nuit*, published in 1933.

1930-63. Freelance photographer. Works for *Le Minotaure, Verve Picture Post, Lilliput, Coronet, Labyrinthe, Réalités, Plaisirs de France*, and especially *Harper's Bazaar*, for which he photographs numerous artists, such as Bonnard, Giacometti, Braque, and Le Corbusier, and writers such as

Thomas Mann, Colette, René Char, Jacques Prévert, and Lawrence Durrell.

1932. E. Tériade introduces him to Picasso, whose sculptures he photographs for the first issue of *Le Minotaure*, a review that lets him get to know the surrealists Breton, Eluard, Desnos, Perret, and Tzara. At Picasso's he meets Dali and Gala, Braque, Max Jacob, Mac Orlan, Kahnweiler. Begins to photograph graffiti.

1933. Exhibition "Groupe annuel des photographes" in Paris, Gallery La Pléiade, with Ilse Bing, Cartier-Bresson, Tabard, Kollar, Man Ray, Kertész, and others.

1934. Receives the Emerson Medal in London for *Paris de nuit*.

1940. Although the Germans are interested, he refuses to request authorization to take pictures, which results in his not being able to publish.

1943. In late September begins to photograph Picasso's sculptures, which he continues working on until the end of 1946.

1944. Mobilized as an officer by the Rumanian army, he goes into hiding at the house of friends. Takes up drawing again.

1945. Meets Gilberte Boyer, whom he marries in 1947. First exhibition of his sketches, Gallery Renou et Colle, rue du Faubourg Saint-Honoré. With his friend Prévert, he creates the sets, using giant photographs, for *Rendezvous* at the Théâtre Sarah-Bernhardt (June 1945). Afterwards, he does the sets for three other plays again using photographs (*En Passant*, a one-act play by Raymond Queneau, at the Théâtre Agnès-Capri, in 1947; *D'amour*

et d'eau fraîche by Elsa Triolet and Jean Rivier, at the Théâtre des Champs-Elysées, in 1949; and Phèdre, a ballet by Georges Auric and Jean Cocteau, at the Paris Opéra, 1950).

1949. Writes a surrealist poem, *Histoire de Marie*, with a preface by Henry Miller.

1957. Receives the gold medal at the Photography Biennial in Venice.

1966. Is awarded, along with Ansel Adams, the American Society of

Magazine Photographers prize.

1973. Named Chevalier des Arts et Lettres.

1974. Receives the medal of the city of Arles.

1976. Named Chevalier de la Légion d'Honneur.

1978. Receives the first national Grand Prize for Photography, in Paris.

1984. Dies on July 7.

BIBLIOGRAPHY

1933. *Paris de nuit.* Photographs by Brassaï, text by Paul Morand, Arts et Métiers Graphiques, Paris, out of print.

1946. *Trente Dessins.* Drawings by Brassaï, poem by Jacques Prévert. Editions Pierre Tisne, Paris, out of print.

1948. *Les Sculptures de Picasso.* Photographs by Brassaï, text by D.H. Kahnweiler. Editions du Chêne, Paris, out of print.

1949. *Camera in Paris.* Photographs by Brassaï. Focal Press, London, out of print.
Histoire de Marie. Introduction by Henry Miller, text by Brassaï. Editions du Point du Jour, Paris, out of print.

1952. *Brassaï.* Photographs and text by Brassaï. Edition Neuf, Paris, out of print.

1954. *Seville en fête.* Photographs by Brassaï, text by Henry de Montherlant and Dominique Aubier. Delpire Editeur, Paris, out of print.

1960. *Paris*, Photographs by Brassaï, text by John Russell, Viking Press, London.

1961. *Graffiti.* Photographs and text by Brassaï *Conversations* with Pablo Picasso. Belser Verlag, Stuttgart; Editions du Temps, Paris, out of print.

1964. *Conversations avec Picasso.* Text

and 53 photographs by Brassaï. Editions Gallimard, Paris.

1966. *Transmutations.* Portfolio of 12 prints by Brassaï. Editions Galerie Les Contards, Lacoste (Vaucluse).

1968. *Brassaï.* Photographs by Brassaï, text by Lawrence Durrell. Museum of Modern Art, New York.

1973. Portfolio of 10 photographs by Brassaï, introduction by A.D. Coleman.

1975. *Henry Miller grandeur nature.* Text and 15 photographs by Brassaï. Editions Gallimard, Paris.

1976. *The Secret Paris of the 30's.* Photographs and text by Brassaï. Pantheon Books, New York; Thames and Hudson, London.

1978. *Henry Miller, rocher heureux.* Text by Brassaï. Editions Gallimard, Paris.

1980. *Brassaï Elohivas* (letters to his parents, 1920-40). Kriterion, Bucharest.

1982. *The Artist of My Life.* Photographs and text by Brassaï. Viking Press, New York; Thames and Hudson, London.

1987. *Paris by Night.* Introduction by Paul Morand. Pantheon Books, New York. UK title *Paris After Dark: Brassaï.* Thames and Hudson, London.

EXHIBITIONS

Solo exhibitions

1933. "Paris de nuit," Batsford Gallery, London.

1946. Palais des Beaux-Arts, Bruxelles.

1952. "Cent Photographies de Brassaï," musée des Beaux-Arts, Nancy.

1955. International Museum of Photography, George Eastman House, Rochester, New York.

1957. "Graffiti," Museum of Modern Art, New York.

1958. "The Language of the Wall: Parisian Graffiti Photographed by Brassaï," Institute of Contemporary Arts, London.

1959. "Eye of Paris," Limelight Gallery, New York.

1960. "Graffiti," Triennale de Milan.

1962. "Graffiti," galerie Daniel-Cordier, Paris.

1963. Brassaï: retrospective, Bibliothèque nationale, Paris.

1964. "Picasso-Brassaï," galerie Madura, Cannes (with the sculpture of Picasso).

1966. Brassaï: retrospective, Kölnischer Kunstverein, Cologne.

1968. Brassaï: retrospective, Museum of Modern Art, New York (traveled for 2 years in North America, South America and Australia).

1970. "L'Art mural par Brassaï," (photographs in color), galerie Rencontres, Paris.

1974. "Hommage à Brassaï," musée Réattu, Arles.

1976. "Le Paris secret des années 30," Marlborough Gallery, New York.

1977. "Le Paris secret des années 30," Marlborough Gallery, Zurich.

1979. The Photographer's Gallery, London. "Artists and Studios." Marlborough Gallery, New York.

Group exhibitions

1932. "Modern European Photographers," Julien Levy Gallery, New York (under of the name of Halasz).

1937. "Photography 1839-1937," Museum of Modern Art, New York.

1939. "Maîtres Photographes contemporains," Palais des Beaux-Arts, Bruxelles.

1951. "Five French Photographers." Museum of Modern Art, New York.

1953. "Post-War European Photography," Museum of Modern Art, New York.

1955. "The Family of Man," Museum of Modern Art, New York.

1963. "Great Photographers," Photokina, Cologne.

1976. "Photographs from the Julien Levy Collection, starting with Atget," Art Institute, Chicago.

1981. "Les Réalismes," Centre Georges-Pompidou, Paris.

1985. "L'Amour fou, Photography and Surrealism," The Corcoran Gallery of Art, Washington; this exhibition traveled to London at the Hayward Gallery in 1986 and to Paris under title "Explosante fixe, photographie et surréalisme," Musée national d'Art moderne, Centre Georges-Pompidou.

PHOTOFILE

The Photofile series is conceived and produced
by the Centre National de la Photographie, Paris,
under the direction of Robert Delpire.